We Like Our Teeth

We Like Our Teeth

Written & Illustrated by
Marcus Allsop

Hohm Press
Prescott, Arizona

Thanks to the entire Hohm Press team.

Cover design, Layout and Interior Design: Zac Parker, Kadak Graphics, Prescott, AZ (www.kadakgraphics.com)

Library of Congress Cataloging-in-Publication Data:

Allsop, Marcus.
 We like our teeth / Marcus Allsop.
 p. cm. ISBN 978-1-890772-86-4 (trade paper : alk. paper)
 1. Dental care--Juvenile literature. 2. Dental hygiene--Juvenile literature. 3. Teeth--Juvenile literature. I. Title.
 RK63.A47 2009
 617.6--dc22 2008034942

HOHM PRESS
P.O. Box 2501
Prescott, AZ 86302
800-381-2700
http://www.hohmpress.com

This book was printed in China.

A Note to Parents & Caregivers

Healthy, bright teeth are possible for everybody. But they *do* require care. With attention to a few simple, daily steps, along with regular dental visits, your children will develop habits of health to last them and their teeth for a lifetime. A bright healthy smile can boost your child's self-confidence and yours too. Here are some important points recommended by dentists everywhere:

1. Just before or around a child's first birthday, they should have a visit with your family dentist.

2. Baby's teeth can be cleaned with a soft damp cloth, twice a day.

3. Do not use a toothbrush on your baby's teeth until she or he is one-year old. After that age, a soft brush is fine. Babies' and children's toothbrushes should be changed every three to four months.

4. Toothpaste can be used after your child is two years old; but just a light smear of paste is enough until the child is three. Children often swallow toothpaste. Using a

small "pea-sized" squeeze will help prevent this. Swallowing a lot of toothpaste can lead to stains on your child's teeth.

5. Juice is best taken *with* meals and not in-between. All sugary drinks are harmful to teeth. It is important not to give your infant juice in a bottle at night. This is a major cause of tooth decay. Water is best.

6. When a child's first teeth have grown together, leaving little space in between, then flossing can begin once a day.

7. Tooth brushing should always be supervised. Dentists and doctors recommend that parents clean their children's teeth, even up to age seven.

8. Healthy snacks prevent tooth decay, and also protect your child from other health issues related to childhood obesity.

9. Learn more information about teeth and good health from your family dentist. Visit the websites listed at the back of this book.

We Like Our Teeth

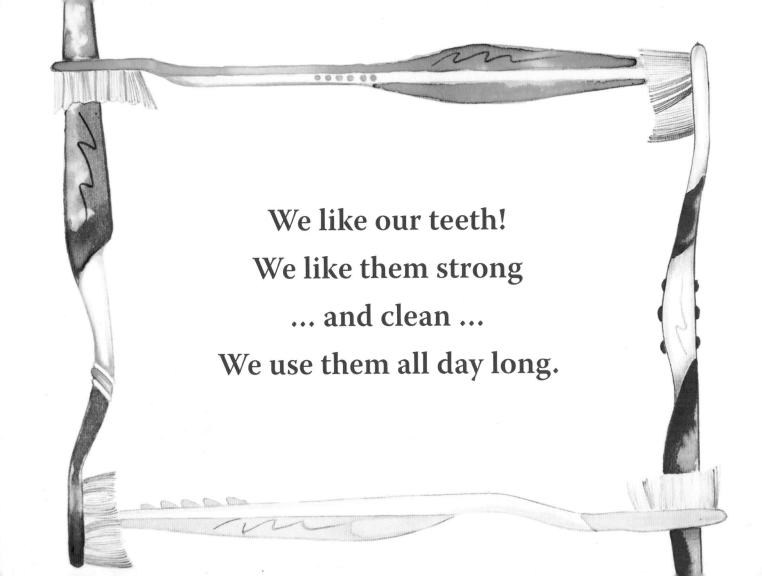

We like our teeth!

We like them strong

... and clean ...

We use them all day long.

Teeth are for chewing,
and speaking just right
Teeth are for chomping,
and smiling so bright

We care for our teeth
in so many ways.
With brushing and flossing
They last all our days.

We brush *all* our teeth,
both the fronts and the backs,
And we eat lots of good foods,
we eat healthy snacks.

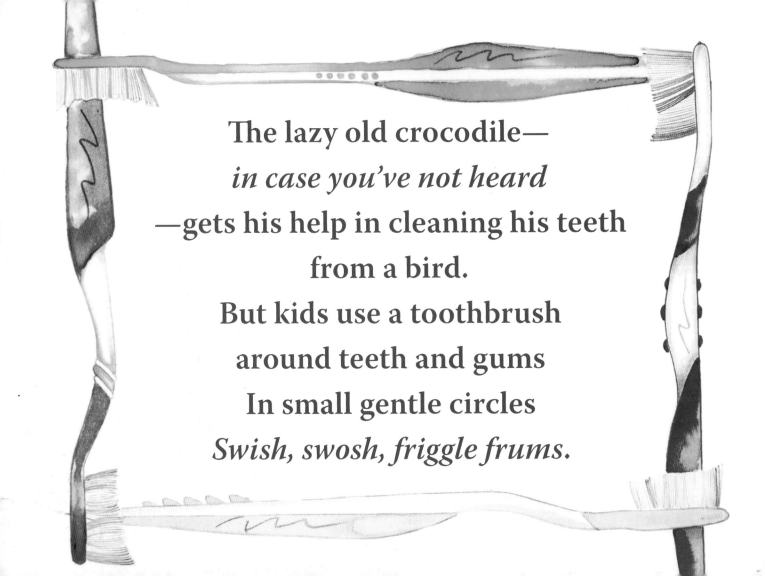

The lazy old crocodile—
in case you've not heard
—gets his help in cleaning his teeth
from a bird.
But kids use a toothbrush
around teeth and gums
In small gentle circles
Swish, swosh, friggle frums.

We brush in the morning
to start the day right
We brush after eating
We brush every night

Toothpaste comes in colors,
gels, powders or pastes
and one pea-sized drop
has lots of good tastes.

Juice drinks at bedtime
hurt teeth, over time,
Water is better,
refreshing and fine

When teeth are well-brushed
then plaque [germs] cannot rest
or lead to decay
and your teeth stay their best.

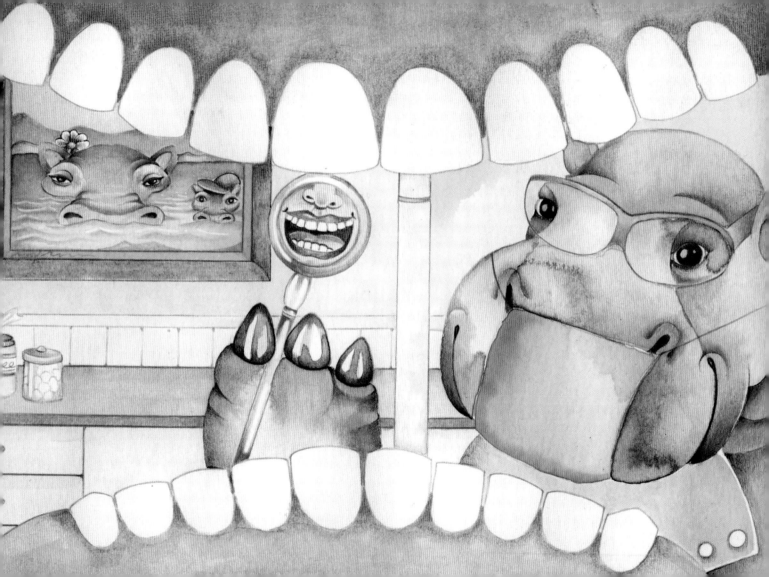

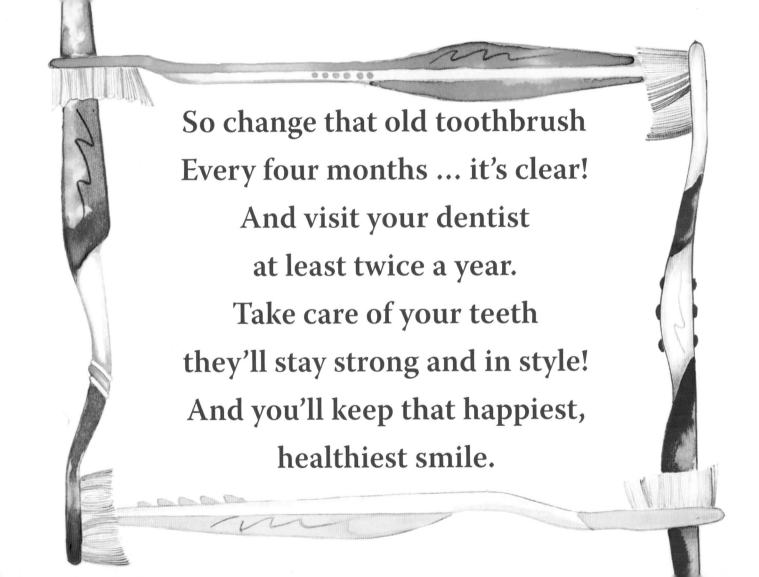

So change that old toothbrush
Every four months … it's clear!
And visit your dentist
at least twice a year.
Take care of your teeth
they'll stay strong and in style!
And you'll keep that happiest,
healthiest smile.

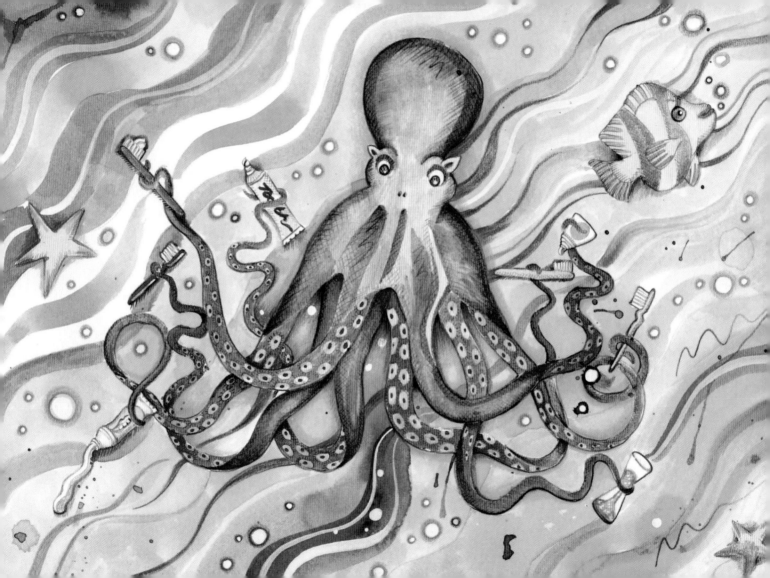

More Information on Dental Health

1. The **American Dental Association** is the oldest and largest national dental association in the world. Their website is: **www.ada.org**

 On the homepage, look for the column labeled "PUBLIC" and click on "Oral Health Topics, A-Z," then search for the subject of your question.

2. To find a pediatric dentist and also for further helpful advice on children's tooth care, the **American Academy of Pediatric Dentistry** has a website: **www.aapd.org**

 If you don't immediately find what you need, then click on the menu option "Parent Resource Center," from the homepage.

3. Information for children, teens and parents about all aspects of health can be found at: **www.kidshealth.org**

 To find entries about teeth and tooth care, type "tooth" in the search box, and you will get the full list to choose from..

OTHER FAMILY HEALTH TITLES FROM HOHM PRESS

We Like To Help Cook
by Marcus Allsop
Illustrations by Diane Iverson
Based on the USDA Food Pyramid guidelines, young children help adults to prepare healthy, delicious foods.
ISBN: 978-890772-70-3, paper, 32 pages, $9.95
Spanish Language Version: *Nos Gusta Ayudar a Cocinar*
ISBN: 978-1-890772-75-8

We Like To Read
by Elyse April
Illustrations by Angie Thompson
This vividly-colored picture book provides a new look at how to teach and encourage reading by using play and "attachment parenting" – i.e., lots of physical closeness and learning by example.
ISBN: 978-1-890772-80-2, paper, 32 pages, $9.95
Spanish/English Bi-lingual Version: *Nos Gusta Leer*
ISBN: 978-1-890772-81-9

We Like To Eat Well
by Elyse April
Illustrations by Lewis Agrell
This book celebrates healthy food, and encourages young children and their caregivers to eat well, and with greater awareness.
ISBN: 978-890772-69-7, paper, 32 pages, $9.95
Spanish Language Version: *Nos Gusta Comer Bien*
ISBN: 978-1-890772-78-9

We Like To Move
by Elyse April
Illustrations by Diane Iverson
This beautifully illustrated book encourages exercise as a prescription for obesity and diabetes in young children.
ISBN: 978-890772-60-4, paper, 32 pages, $9.95. Spanish Language Version: *Nos Gusta Movernos*
ISBN: 978-890772-65-9

TO ORDER: 800-381-2700, or visit our website, www.hohmpress.com *Special discounts for bulk orders.

OTHER FAMILY HEALTH TITLES FROM HOHM PRESS

We Like To Nurse
by Chia Martin
Illustrations by Shukyo Rainey
Captivating illustrations present mother animals nursing their young, and honors the mother-child bond created by nursing.
ISBN: 978-934252-45-4, paper, 32 pages, $9.95
Spanish Language Version: *Nos Gusta Amamanatar*
ISBN: 978-890772-41-3

Breastfeeding:
Your Priceless Gift to Your Baby and Yourself
by Regina Sara Ryan and Deborah Auletta, RN, IBCLC
Pleads the case for breastfeeding as the healthiest option for both baby and mom with gorgeous photos and 20 compelling reasons why breastfeeding is best.
ISBN: 978-1-890772-48-2, paper, 32 pages, $9.95. Spanish Language Version: *Amamantar* ISBN: 978-1-890772-57-4

Being Born:
The Doula's Role
by Jewel Hernandez
Illustrations by R. Michael Mithuna
With simple text and soft water-colors this book explains in friendly terms to kids and parents about the role of a doula – a healthcare professional who offers physical and emotional support to a pregnant woman and her family.
ISBN: 978-1-890772-83-3, paper, 32 pages, $9.95

We Like to Play Music
by Kate Parker
An easy-to-read picture book full of actual photographs of children playing music, moving to a beat and enjoying music alone and with parents and peers. The rhyming text says how everyone can play music, emphasizing that no special training is needed to shake a rattle, dance to a beat, or even to form your own "band."
ISBN: 978-1-890772-85-7, paper, 32 pages, $9.95

TO ORDER: 800-381-2700, or visit our website, www.hohmpress.com *Special discounts for bulk orders.